Dreaming Dark

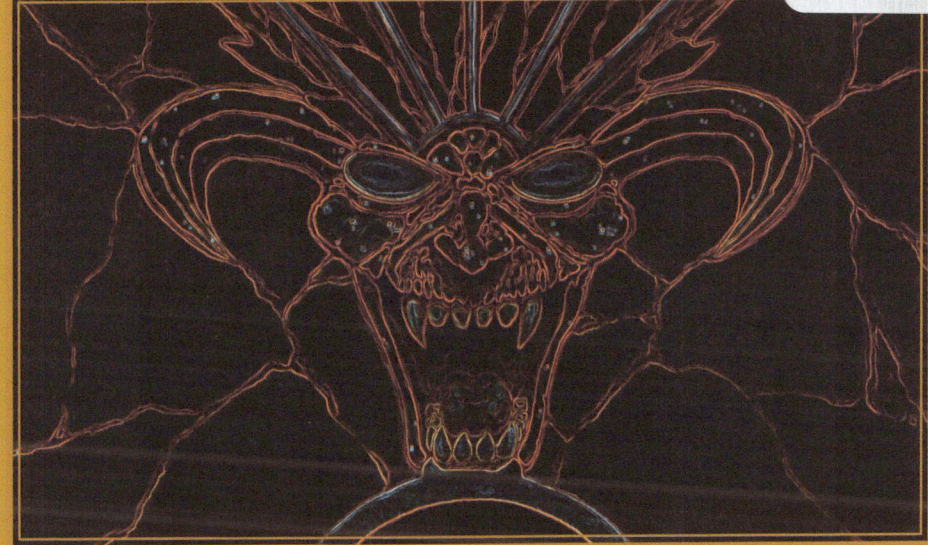

The Fantasy Art of
DX Stone

Nuance Press

Dreaming Dark: The Fantasy Art of D X Stone Volume I
Copyright © 2012 Nuance Press
All rights reserved.

ISBN-13: 978-0615620985

www.nuancepress.com

FOREWORD:
ANOTHER POUND OF FLESH

As the subway sounds surround you
Flow around you and you step inside
The doors close like a hungry mouth
You're headed south–enjoy the ride
Outside the windows flash
Rock, earth and ash–it blurs together
You listen to the thunder
And you wonder 'bout the weather...

And the reckless engineer
Grins ear to ear and pulls the wire:
The whistle blows
And the coal-man throws
Another pound of flesh on the fire

The rail's rather bumpy
Seats are lumpy, torn and pitted
You cannot make a sound or move around
It's not permitted
And no one cries or stirs
The passengers are mostly snoring
You stare at strangers' faces
Or the spaces in the flooring...

And the reckless engineer
Grins ear to ear and pulls the wire:
The whistle blows
And the coal-man throws
Another pound of flesh on the fire

The engine chews through earth descending
On its journey never-ending
The hungry worm turns in the earth
In its deadly bite rebirth
Circular its constant trail
Feeding on its bleeding tail
The whistle shrieks–come join the chorus
Ride the maddened Orobourus
Race and chase–don't look around
To see behind you, gaining ground
The shadowed stalker, all-devouring
Overheating, overpowering
Growing, looming–all-consuming
Here comes your station:

Annihilation.

As the subway sounds surround you
Flow around you and you step inside
The doors close like a hungry mouth
You're headed south–enjoy the ride
Outside the windows flash
Rock, earth and ash–it blurs together
You listen to the thunder
And you wonder 'bout the weather...

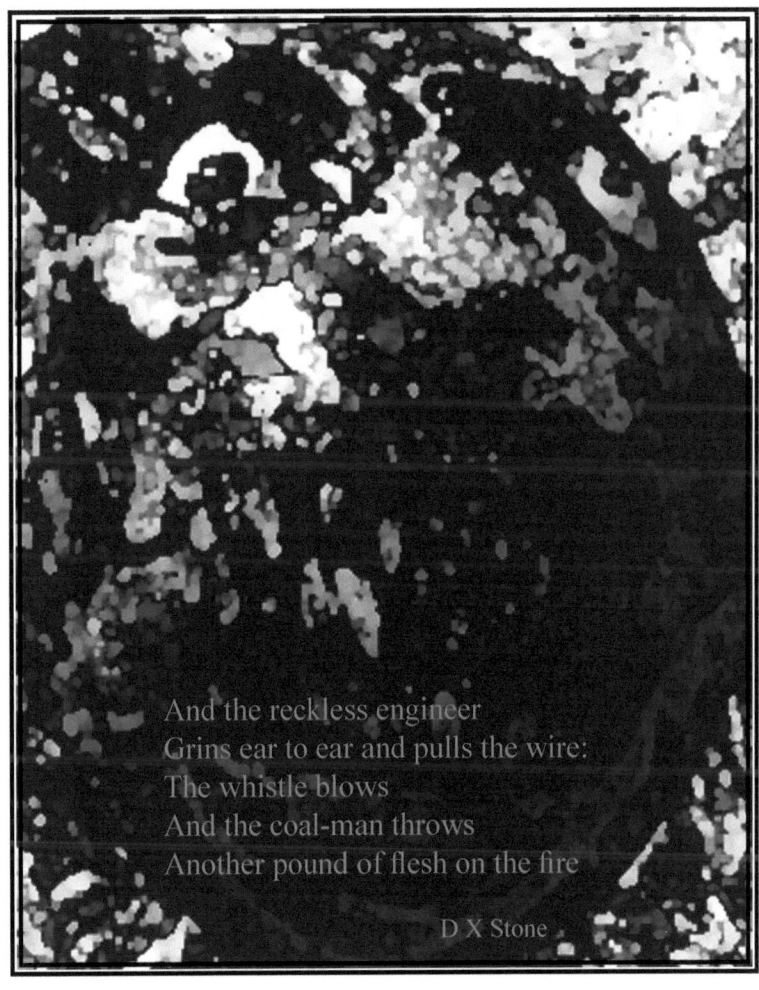

And the reckless engineer
Grins ear to ear and pulls the wire:
The whistle blows
And the coal-man throws
Another pound of flesh on the fire

D X Stone

The job of the artist is always to deepen the mystery.

Francis Bacon

When You're Smiling – 2003, digital media

THE FANTASY ART OF D X STONE

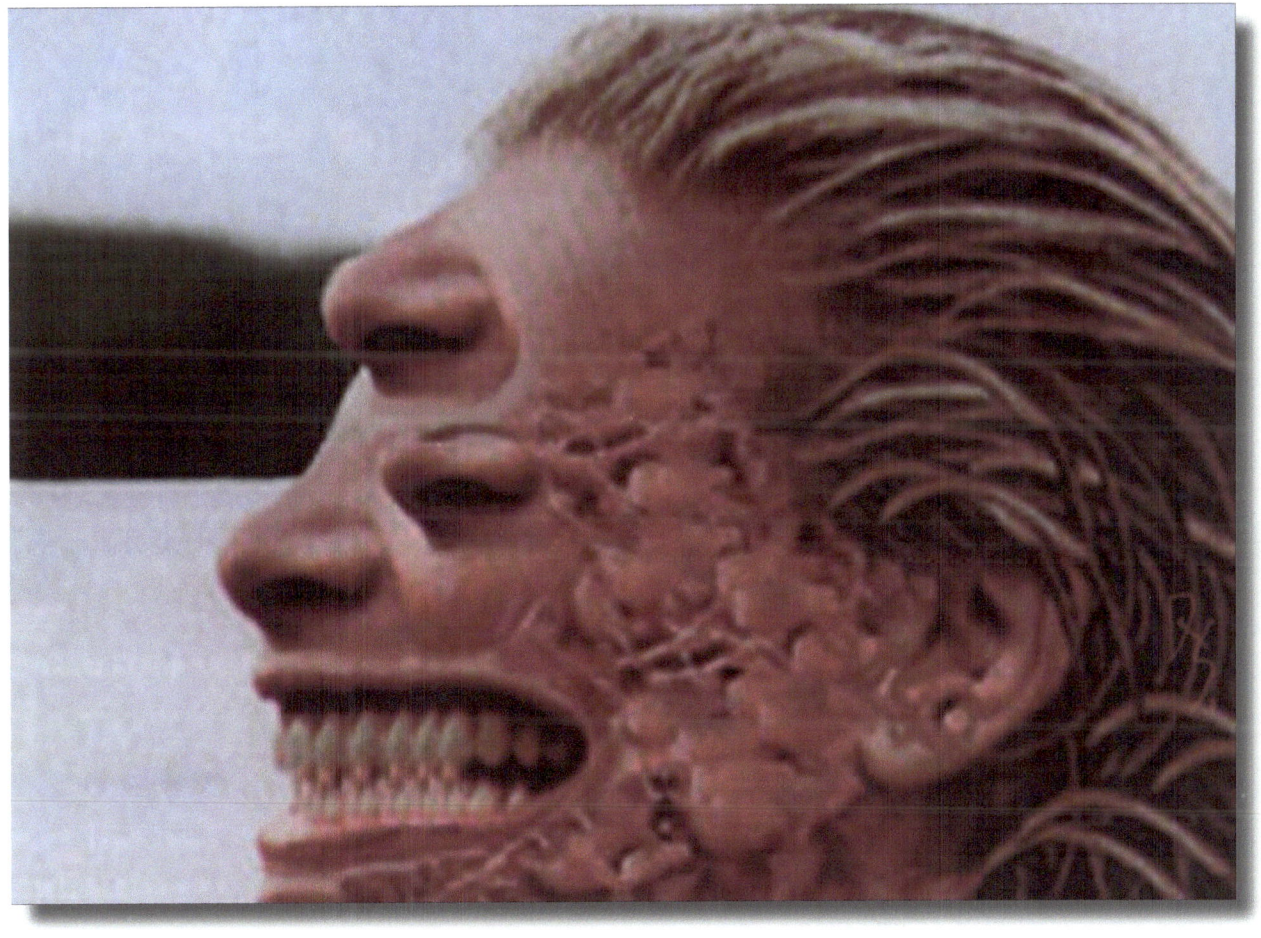

DREAMING DARK

"But I don't want to go among mad people," Alice remarked.

Oh, you can't help that," said the Cat: "we're all mad here.

I'm mad. You're mad."

"How do you know I'm mad?" said Alice.

"You must be," said the Cat,

"or you wouldn't have come here."

Lewis Carroll, Alice's Adventures in Wonderland

Demon III – 2011, pastel/digital media

THE FANTASY ART OF D X STONE

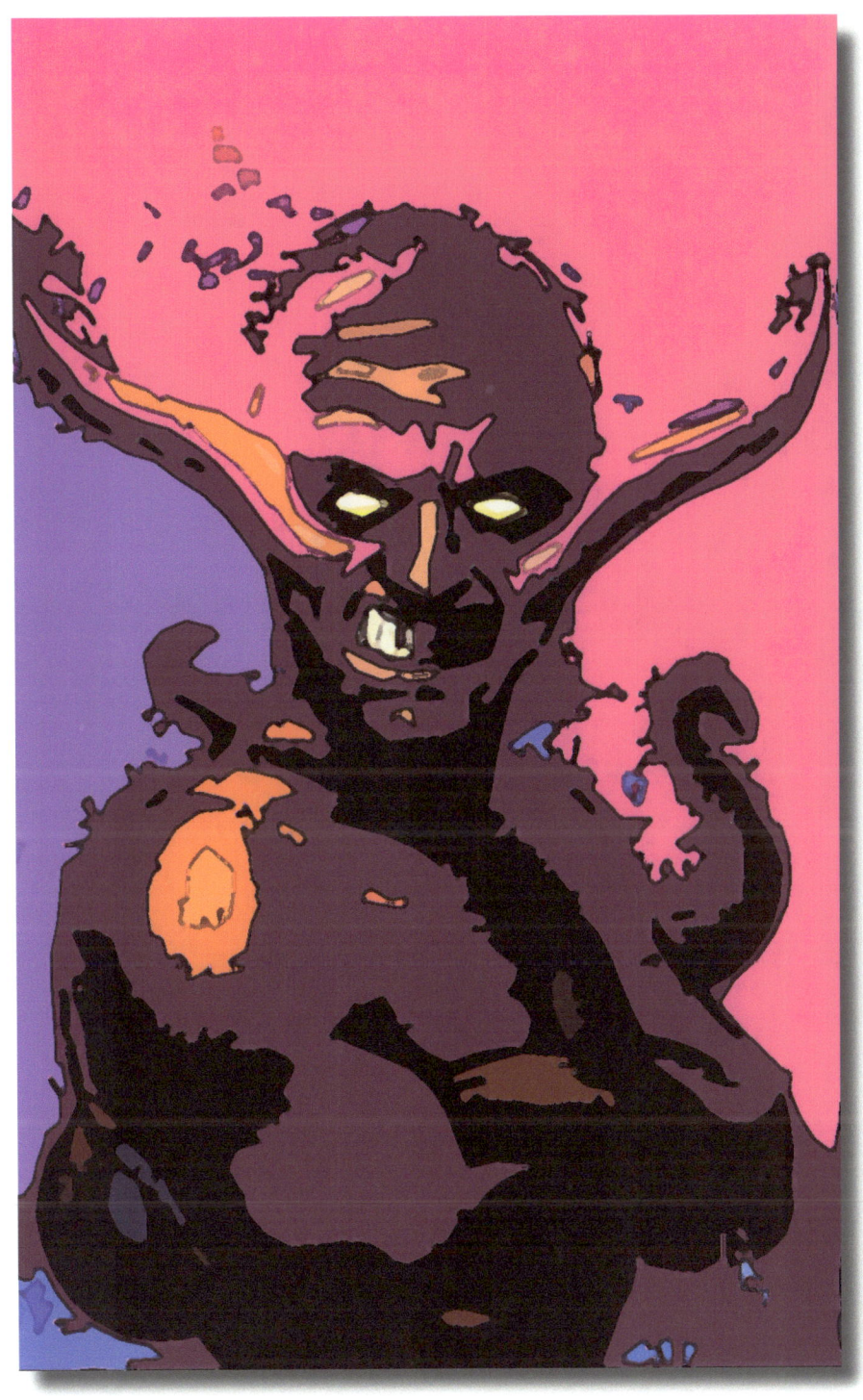

DREAMING DARK

I am not strange.
I am just not normal.

Salvador Dali

Totems – 2010, digital media

THE FANTASY ART OF D X STONE

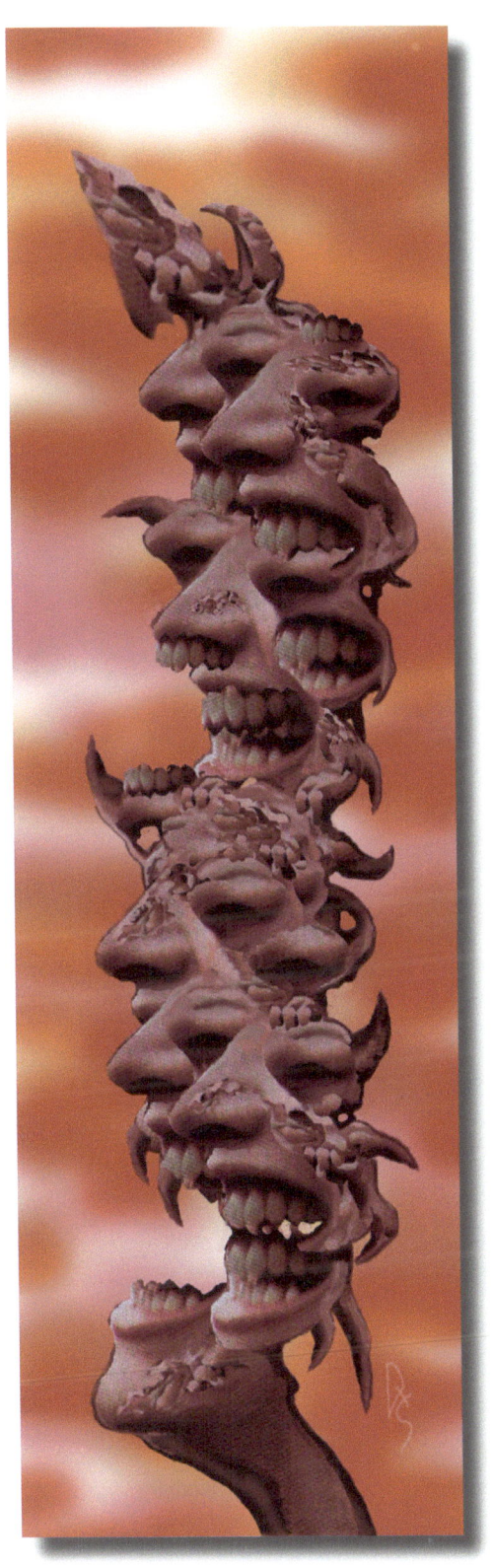

DREAMING DARK

Alice came to a fork in the road.
"Which road do I take?" she asked.

"Where do you want to go?"
responded the Cheshire Cat.

"I don't know," Alice answered.

"Then," said the Cat,

"it doesn't matter."

Lewis Carroll

Dreams are illustrations... from the book your soul is writing about you.
Marsha Norman

Balance - 2007, watercolor

THE FANTASY ART OF D X STONE

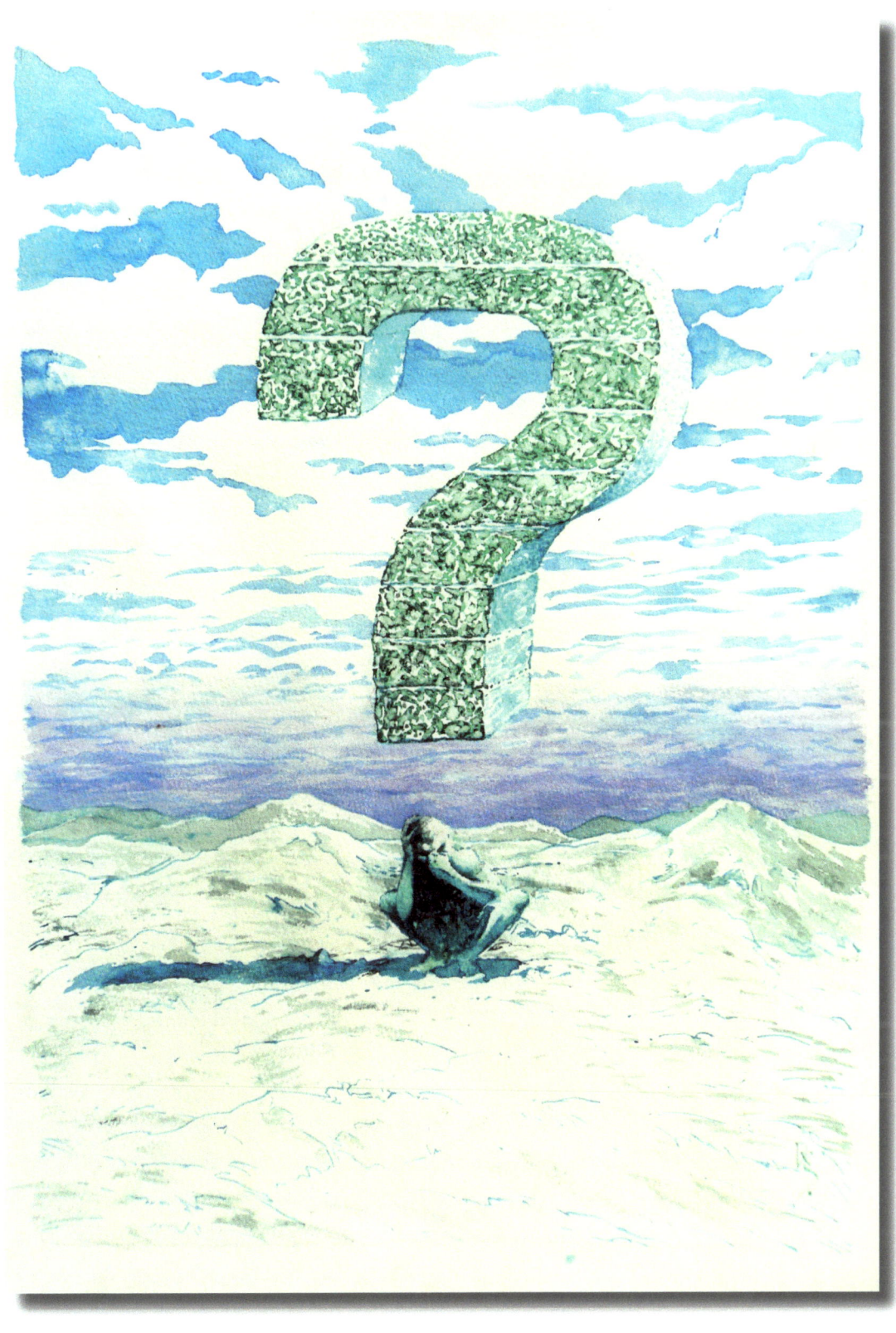

DREAMING DARK

A dream is a microscope through which we look at the hidden occurrences in our soul.

Erich Fromm

The dream is the small hidden door in the deepest and most intimate sanctum of the soul, which opens to that primeval cosmic night that was soul long before there was conscious ego and will be soul far beyond what a conscious ego could ever reach.

Carl Jung

Life is like arriving late for a movie, having to figure out what was going on without bothering everybody with a lot of questions, and then being unexpectedly called away before you find out how it ends.

Joseph Campbell

Dreams are symbolic in order that they cannot be understood; in order that the wish, which is the source of the dream, may remain unknown.

Carl Jung

Shriek – 2011, oil/digital media

THE FANTASY ART OF D X STONE

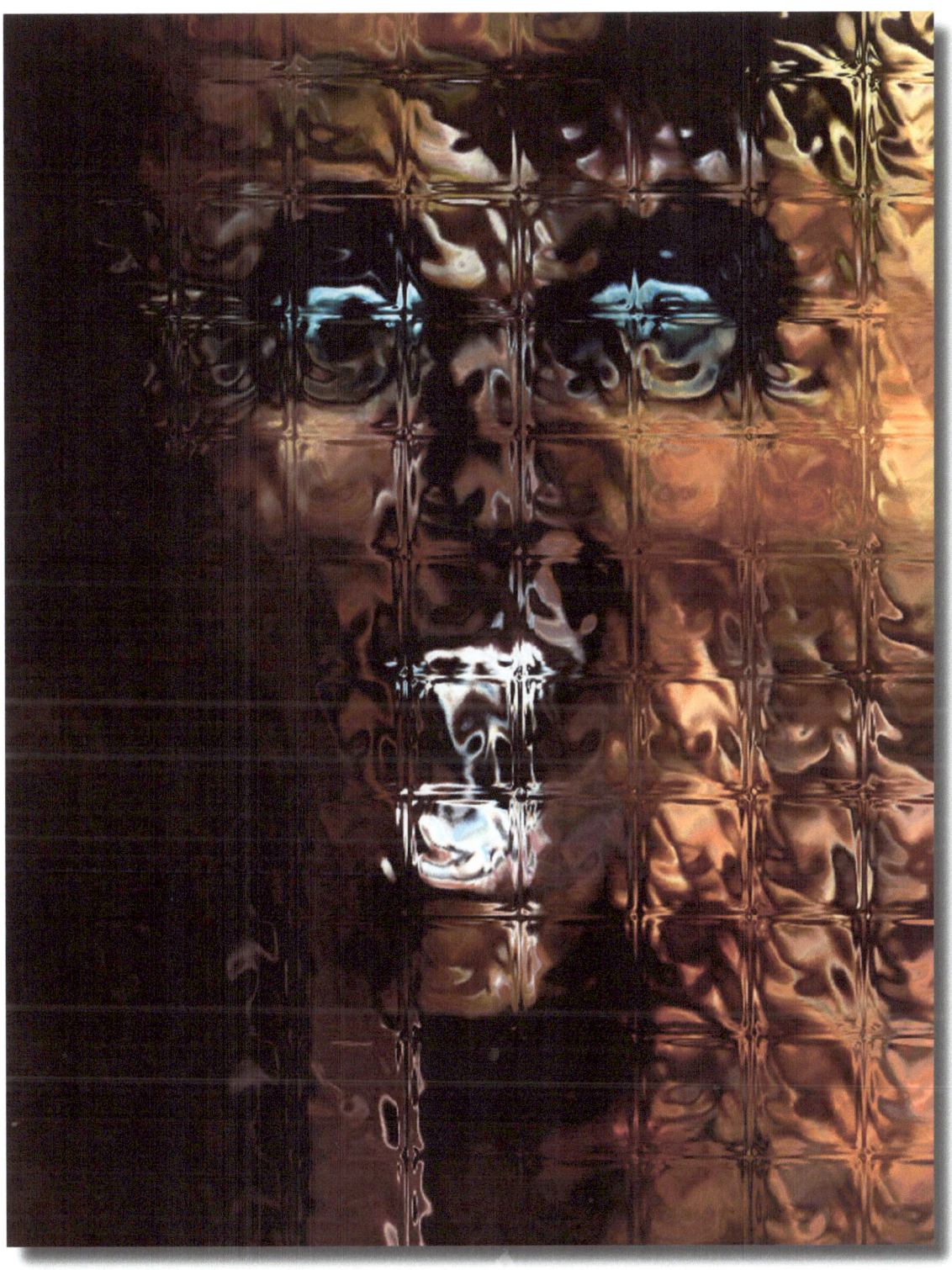

DREAMING DARK

Lamia – 2009, digital media

THE FANTASY ART OF D X STONE

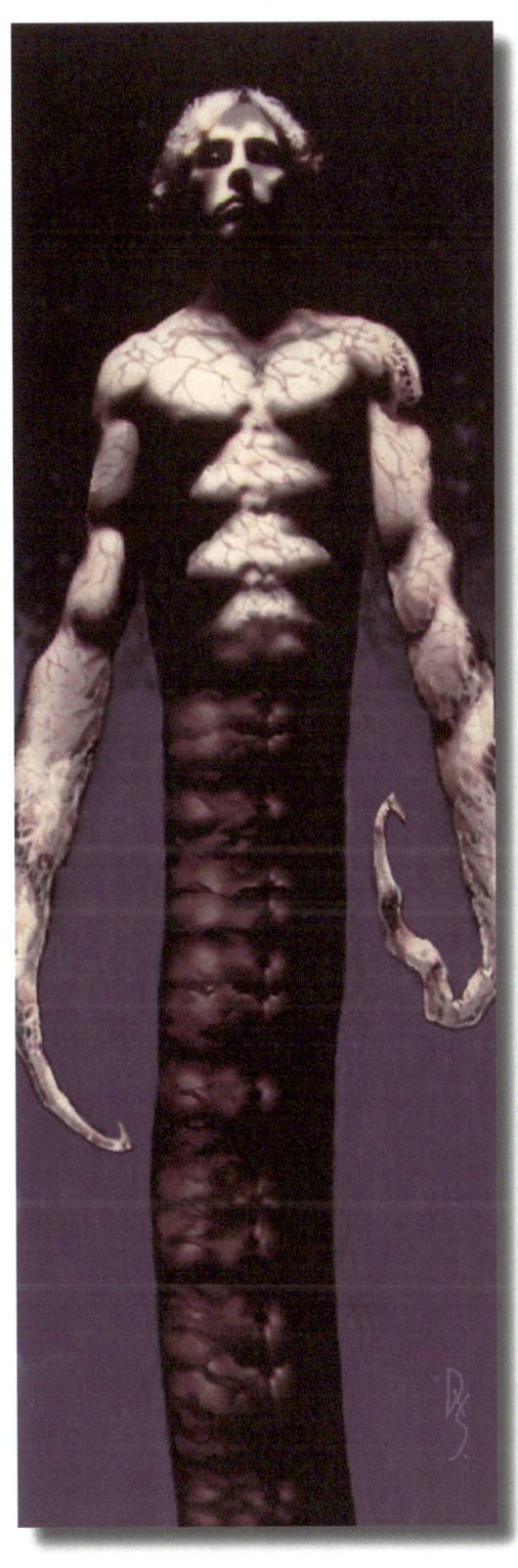

DREAMING DARK

"I–I'm a little girl," said Alice, rather doubtfully, as she remembered the number of changes she had gone through that day...

"Curiouser and curiouser!"

"I know who I WAS when I got up this morning, but I think I must have been changed several times since then!"

"But if I'm not the same, the next question is,

'Who in the world am I?'

Ah, that's the great puzzle!"

Lewis Carroll

Away Station – 1987, oil on canvas/digital media

THE FANTASY ART OF D X STONE

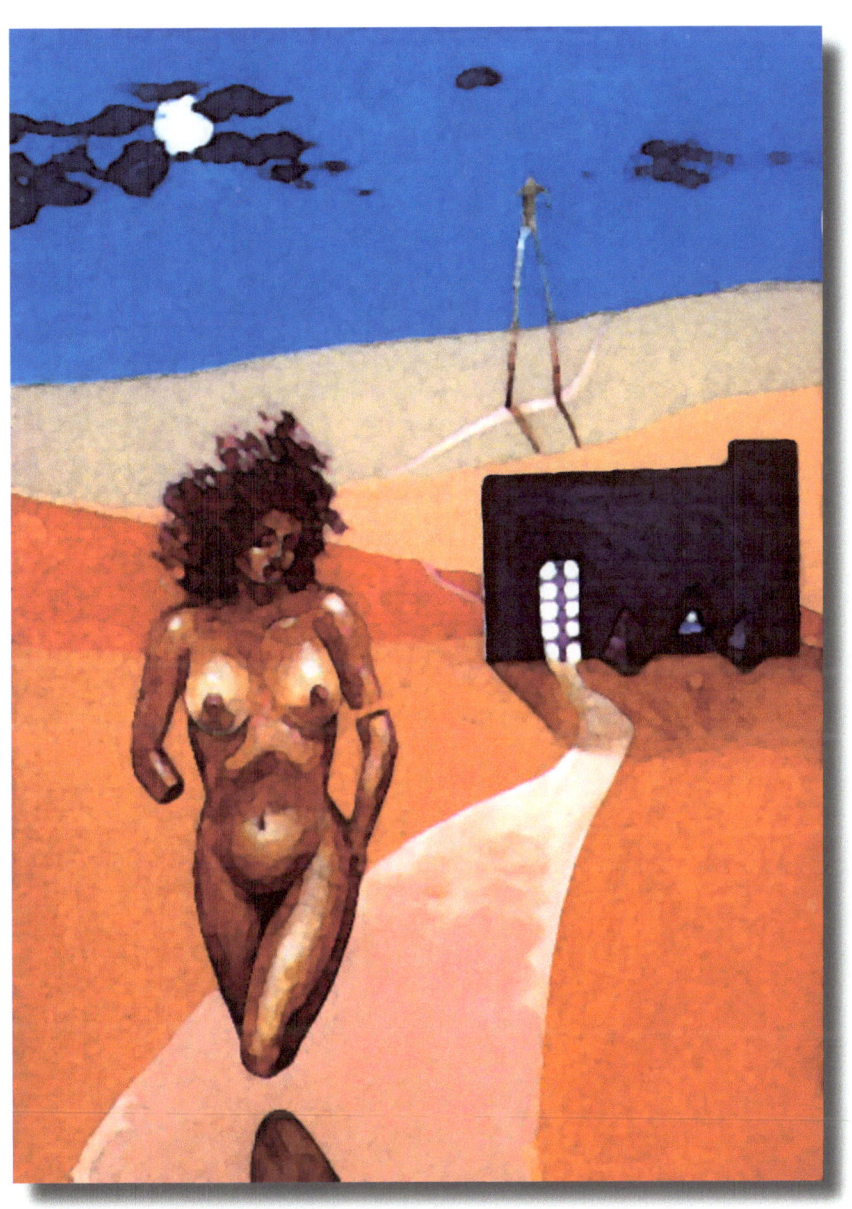

DREAMING DARK

The general function of dreams is to try to restore our psychological balance by producing dream material that re-establishes, in a subtle way, the total psychic equilibrium.

Carl Jung, Man and His Symbols

"You would have to be half-mad to dream me up."

Lewis Carroll, Alice in Wonderland

Legion – 2005, digital media

THE FANTASY ART OF D X STONE

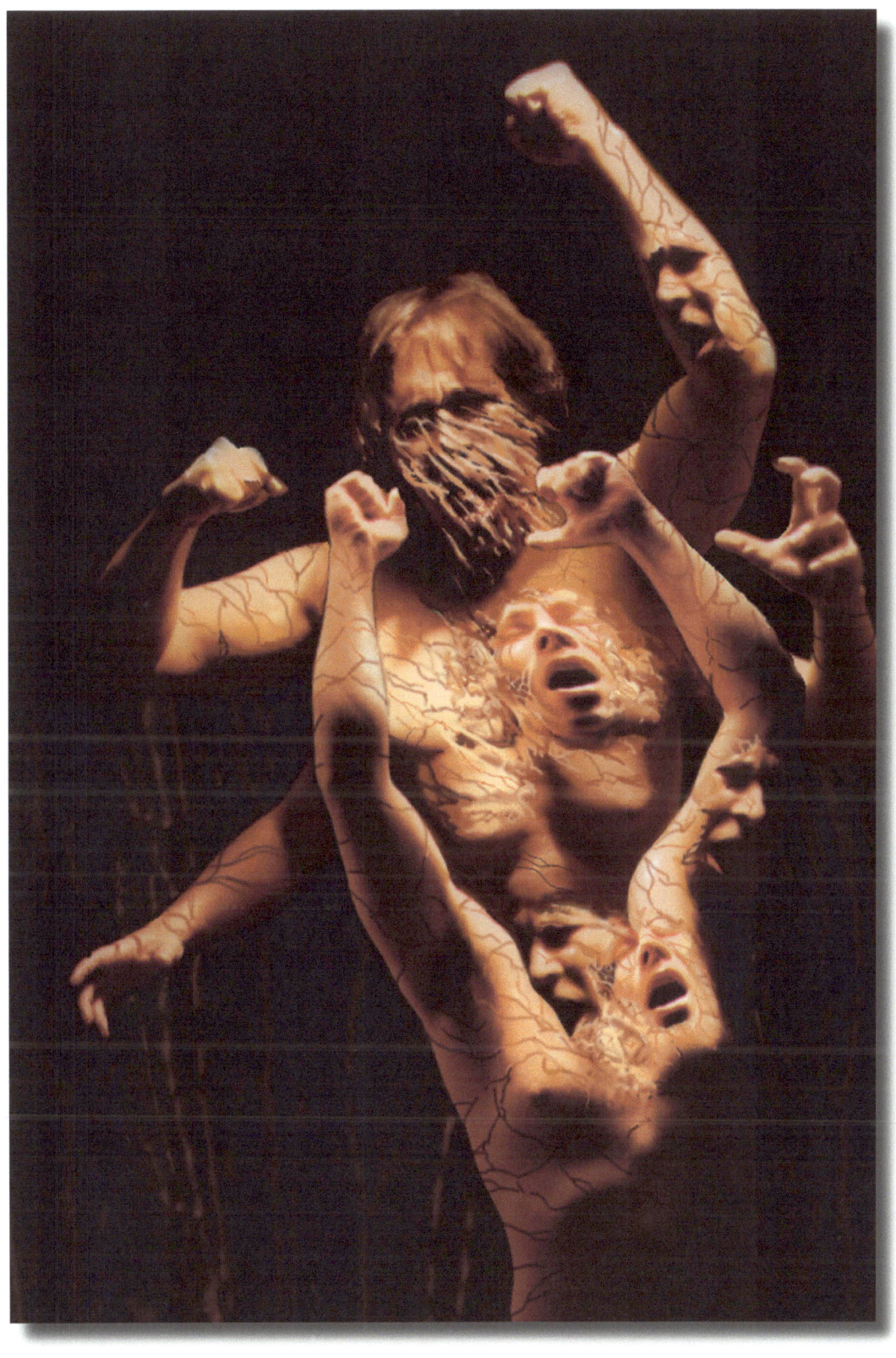

DREAMING DARK

I'm not afraid of death, I just don't want to be there when it happens.

"Fantasy, abandoned by reason, produces impossible monsters; united with it, she is the mother of the arts and the origin of marvels."

Goya

Woody Allen

Jaws of Life – 2001, pastel

THE FANTASY ART OF D X STONE

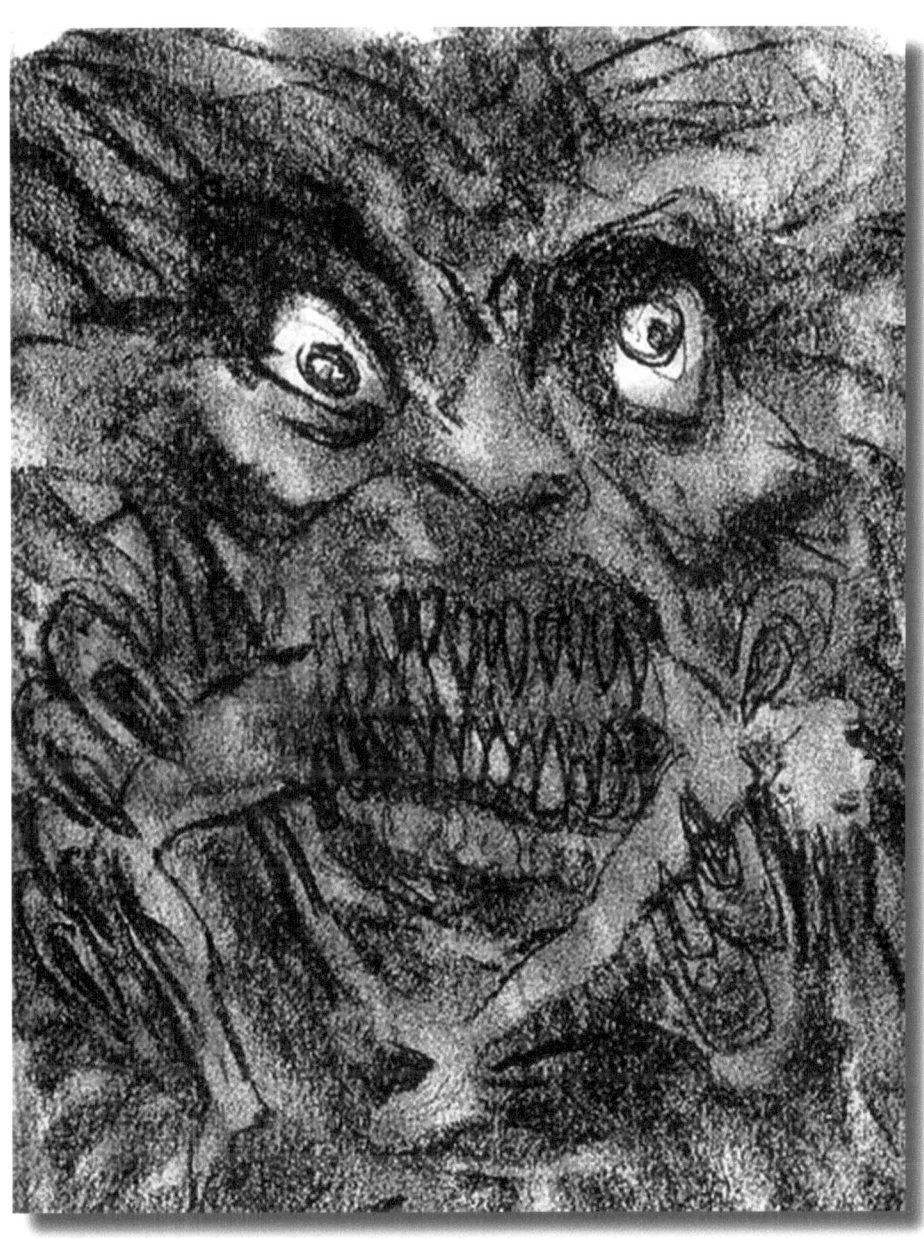

DREAMING DARK

I have never seen a greater
monster or miracle in the world
than myself.

Michel de Montaigne

"I'm not myself, you see."

"If the doors of perception were cleansed every thing would appear to man as it is, Infinite. For man has closed himself up, till he sees all things thro' narrow chinks of his cavern."

William Blake

Judgement - 2008, watercolor

THE FANTASY ART OF D X STONE

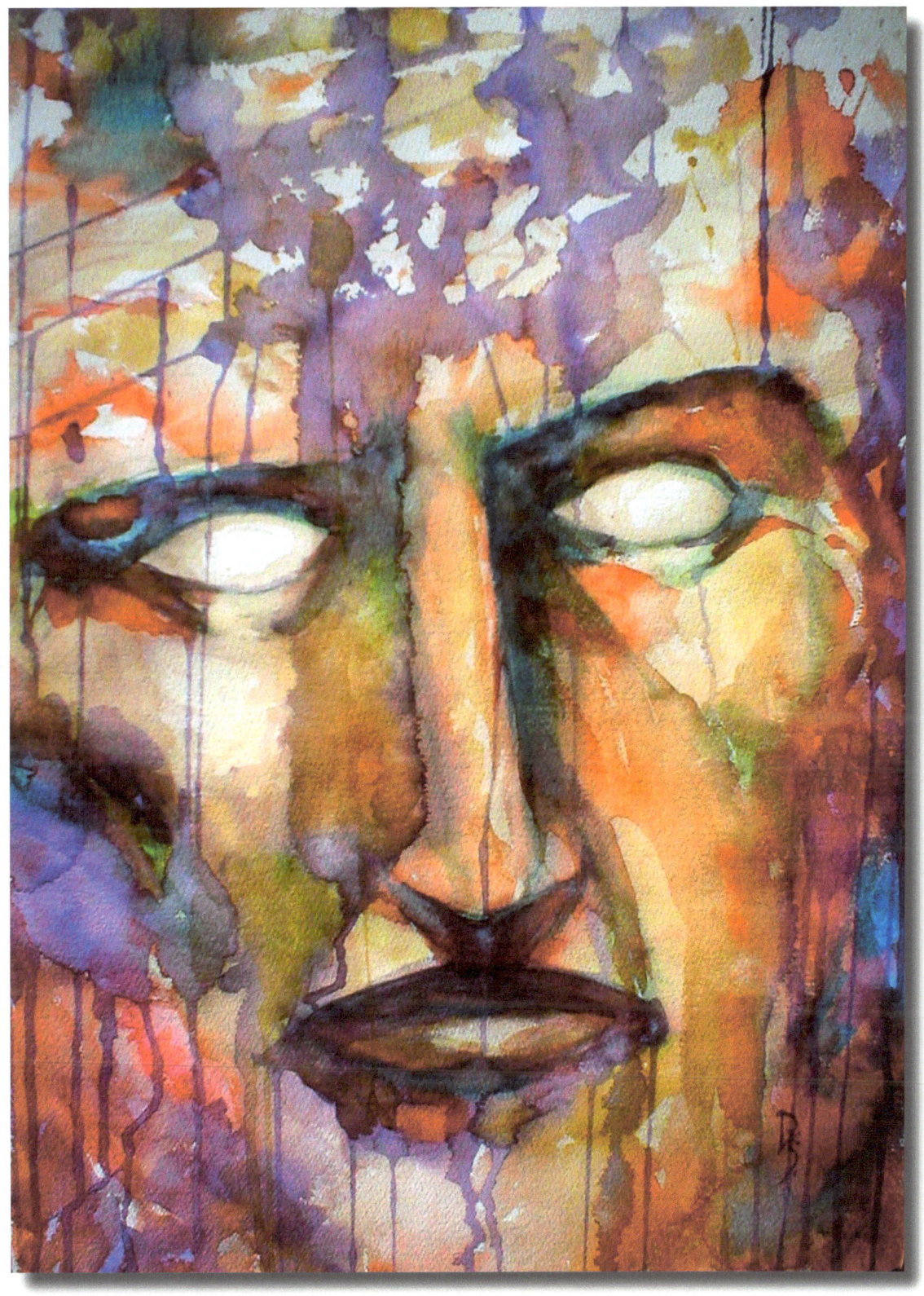

DREAMING DARK

written I should be loyal
to the nightmare of my choice.

Joseph Conrad

To live without Hope
is to Cease to live.

Fyodor Dostoevsky

Isolation is the sum total of
wretchedness to a man.

Thomas Carlyle

An unfulfilled vocation
drains the color from a man's
entire existence.

Honoré de Balzac

The Long Road – 1985, oil on canvas

THE FANTASY ART OF D X STONE

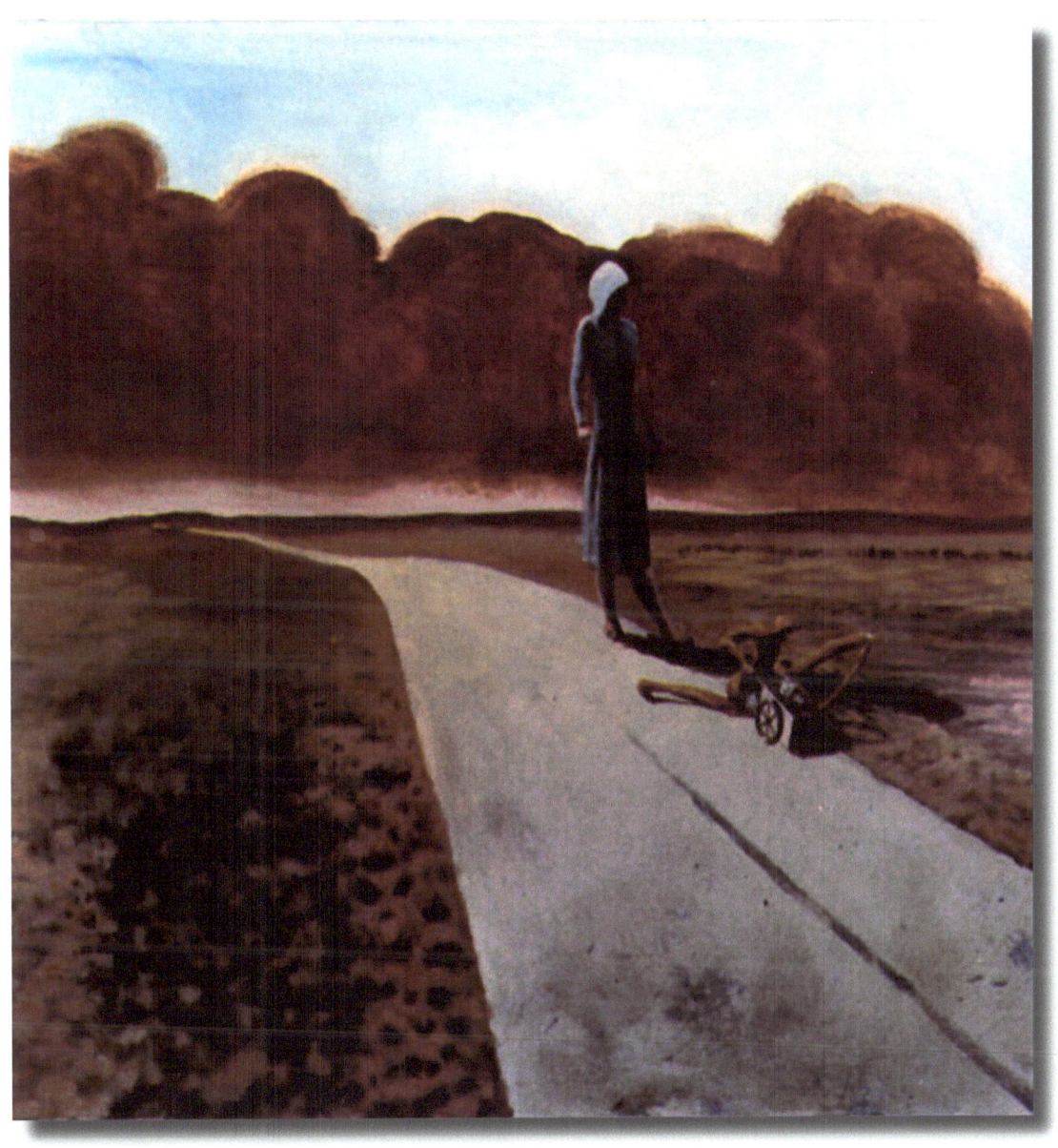

DREAMING DARK

You have wakened not out of sleep, but into a prior dream, and that dream lies within another, and so on, to infinity, which is the number of grains of sand. The path that you are to take is endless, and you will die before you have truly awakened.

Jorge Luis Borges

Confusion –2000, pastel

THE FANTASY ART OF D X STONE

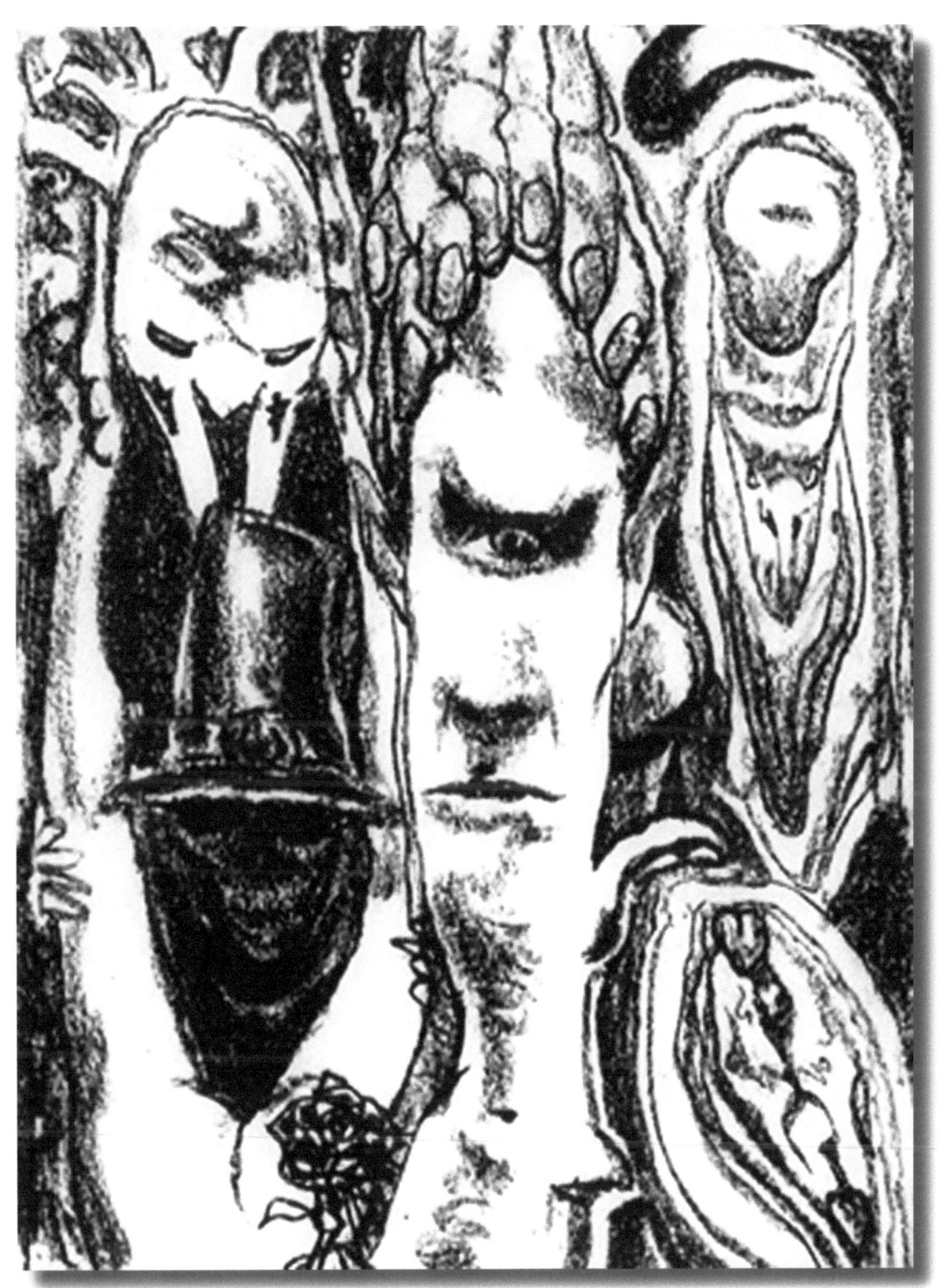

DREAMING DARK

The most important thing in art is The Frame. For painting: literally; for other arts: figuratively—because, without this humble appliance, you can't know where The Art stops and The Real World begins. You have to put a 'box' around it because otherwise, "What is that shit on the wall?
 Frank Zappa

Christina's Other World – 1985, oil on canvas/digital media

THE FANTASY ART OF D X STONE

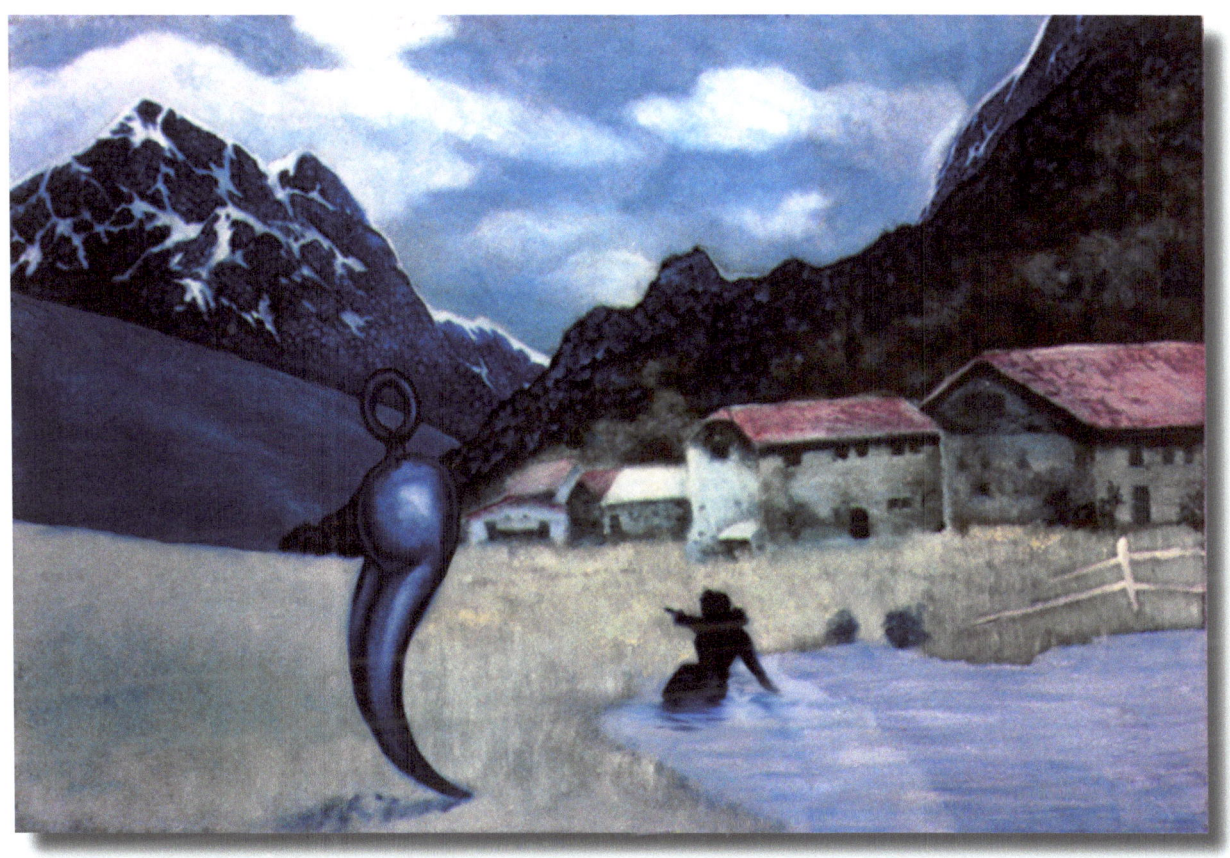

DREAMING DARK

> It is sometimes an appropriate response to reality to go insane.
>
> Philip K. Dick

Bad Trip (detail) – 2011, gouache/digital media

THE FANTASY ART OF D X STONE

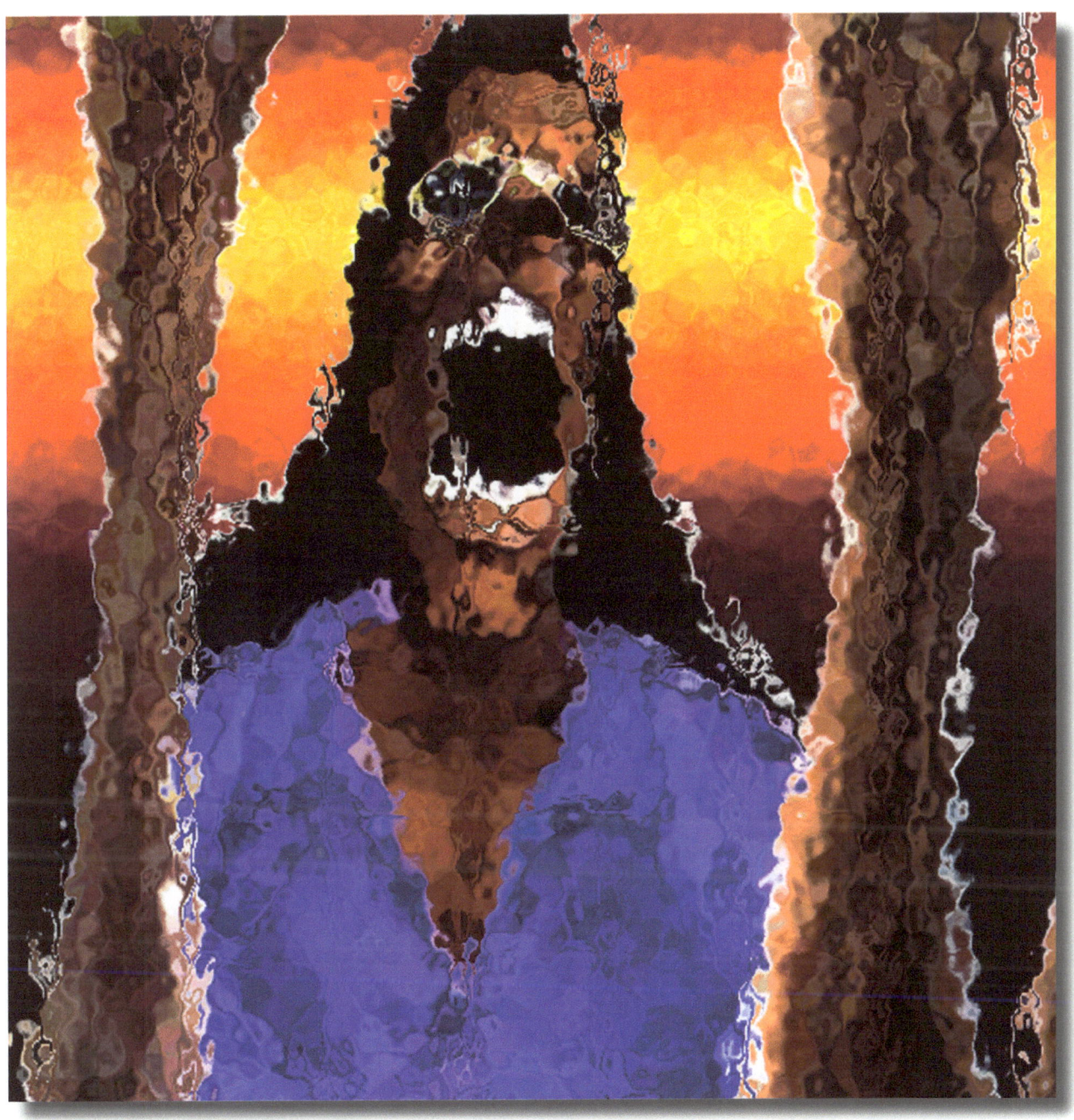

DREAMING DARK

The ability to "fantasize" is the ability to survive. It's wonderful to speak about this subject because there have been so many wrong-headed people dealing with it.... The so-called realists are trying to drive us insane, and I refuse to be driven insane.... We survive by fantasizing. Take that away from us and the whole damned human race goes down the drain.

Ray Bradbury

Sentinel – 1984, oil on canvas

THE FANTASY ART OF D X STONE

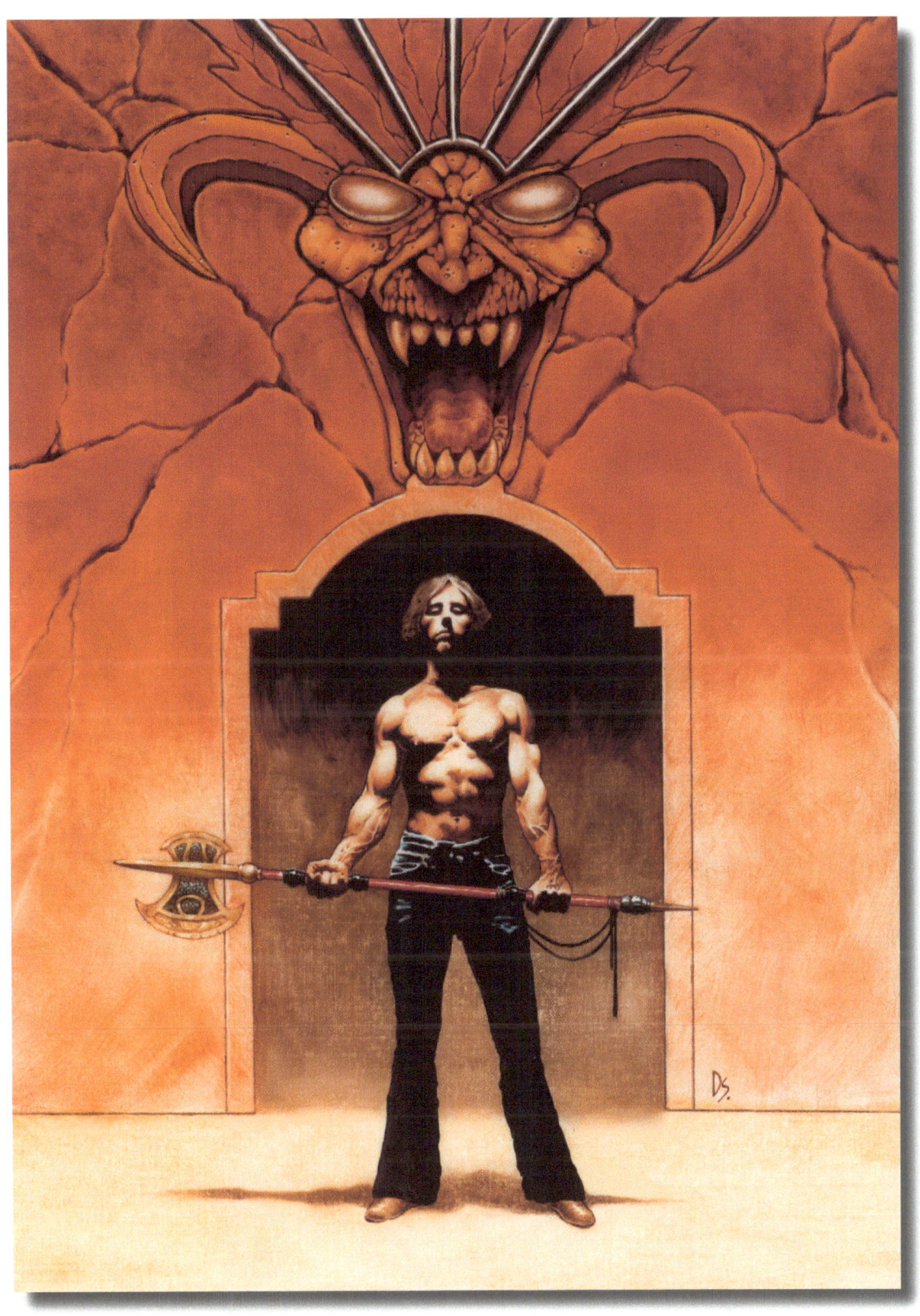

DREAMING DARK

> Reality is whatever refuses to go away when I stop believing in it.
>
> Philip K Dick

> Reality is frequently inaccurate.
>
> Douglas Adams

Angel Dark – 1985, oil on canvas

THE FANTASY ART OF D X STONE

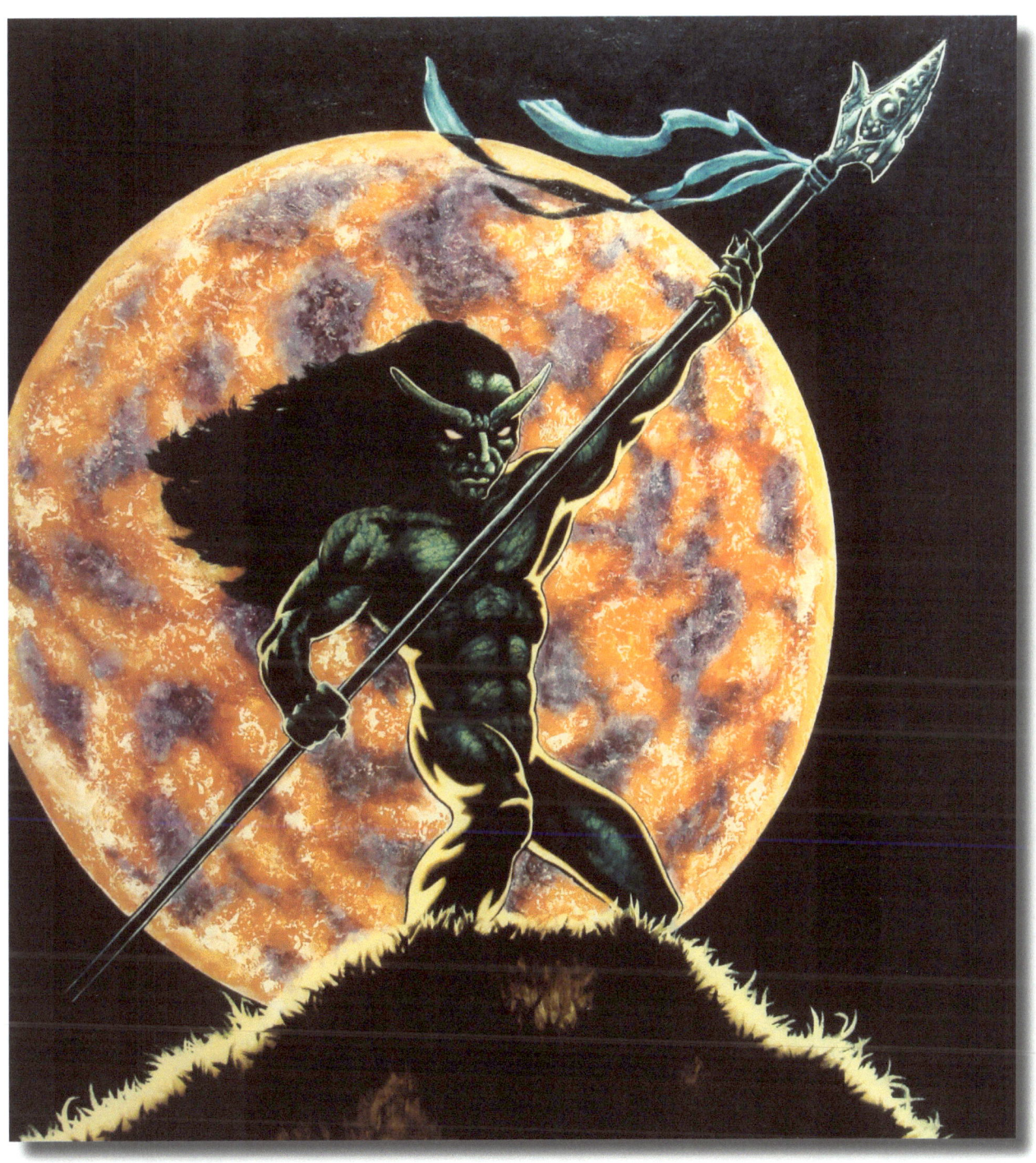

DREAMING DARK

Art attracts us only by what it reveals of our most secret self.

Jean-Luc Godard

Zanzibar Nights - 2000, pastel

THE FANTASY ART OF D X STONE

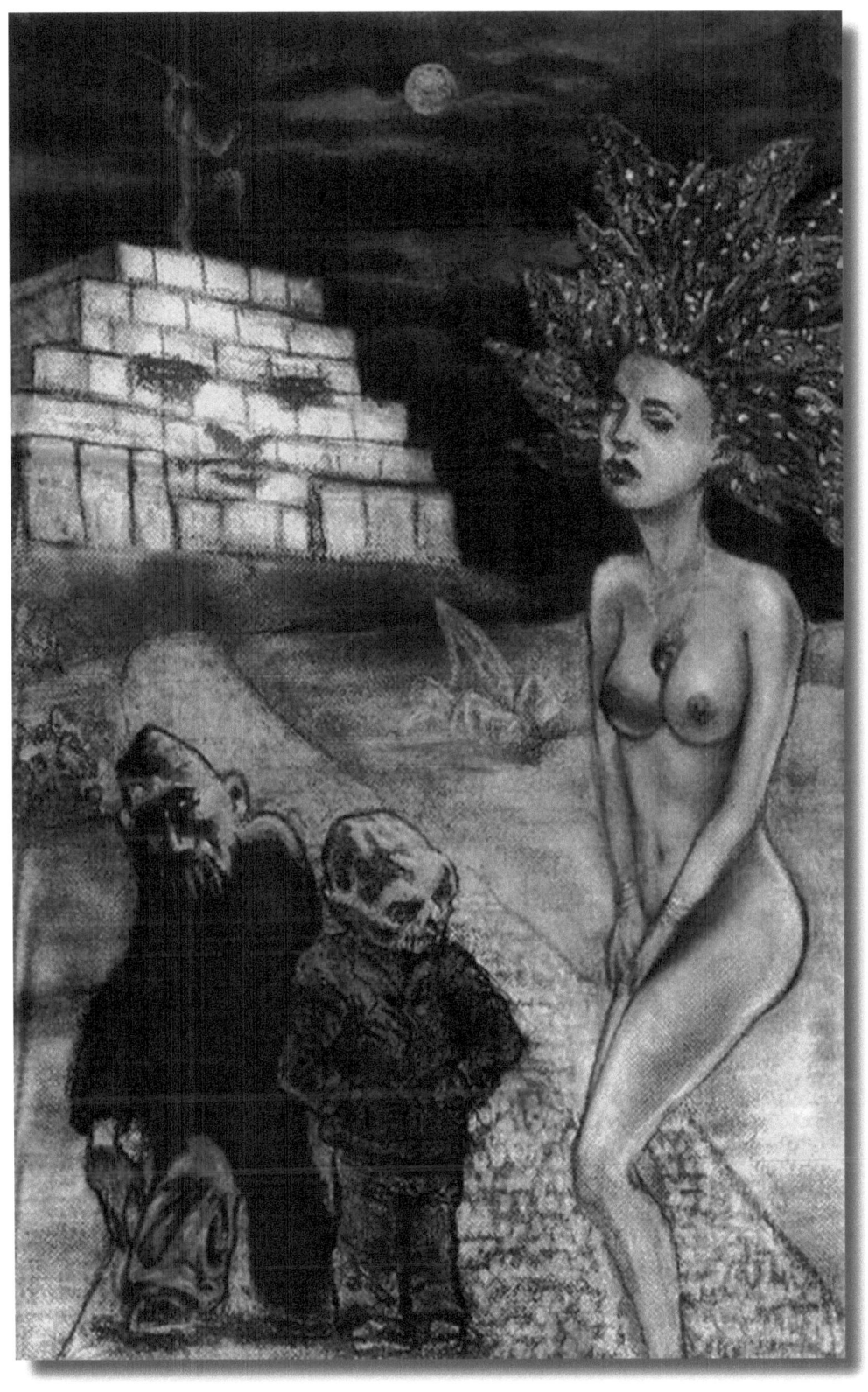

DREAMING DARK

He was part of my dream, of course— but then I was part of his dream, too.

Lewis Carroll

Summons – 1976, oil on canvas

THE FANTASY ART OF D X STONE

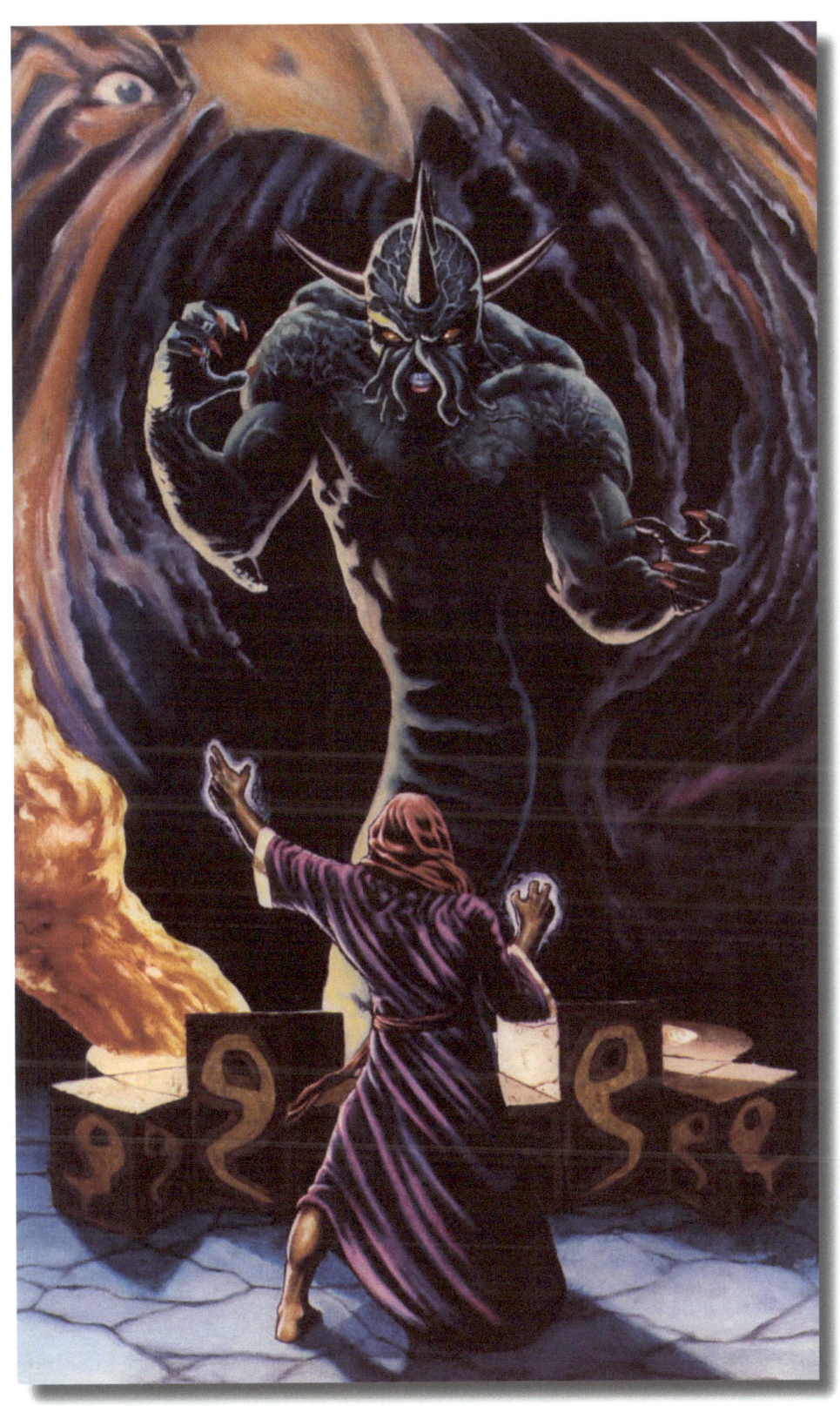

DREAMING DARK

> I couldn't commit suicide if my life depended on it.
> — George Carlin

> Everybody is bookish; where everyone is bloodied, we revel, we rejoice.
> — Clive Barker

Out of The Dark – 1984, oil on canvas

THE FANTASY ART OF D X STONE

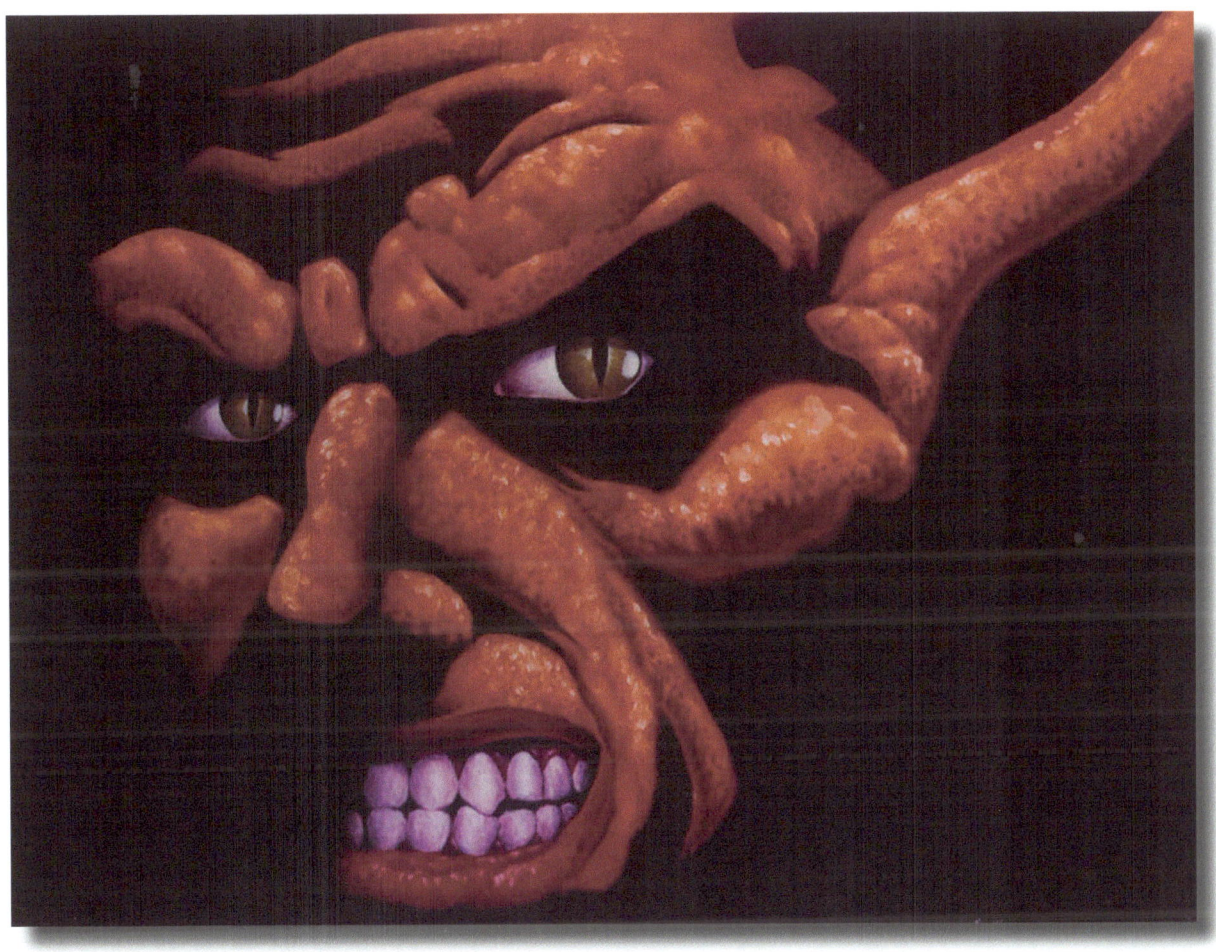

DREAMING DARK

> Insanity is relative. It depends on who has who locked in what cage.
>
> Ray Bradbury

A Hard Day's Dark Knight – 2011, pastel/digital media

THE FANTASY ART OF D X STONE

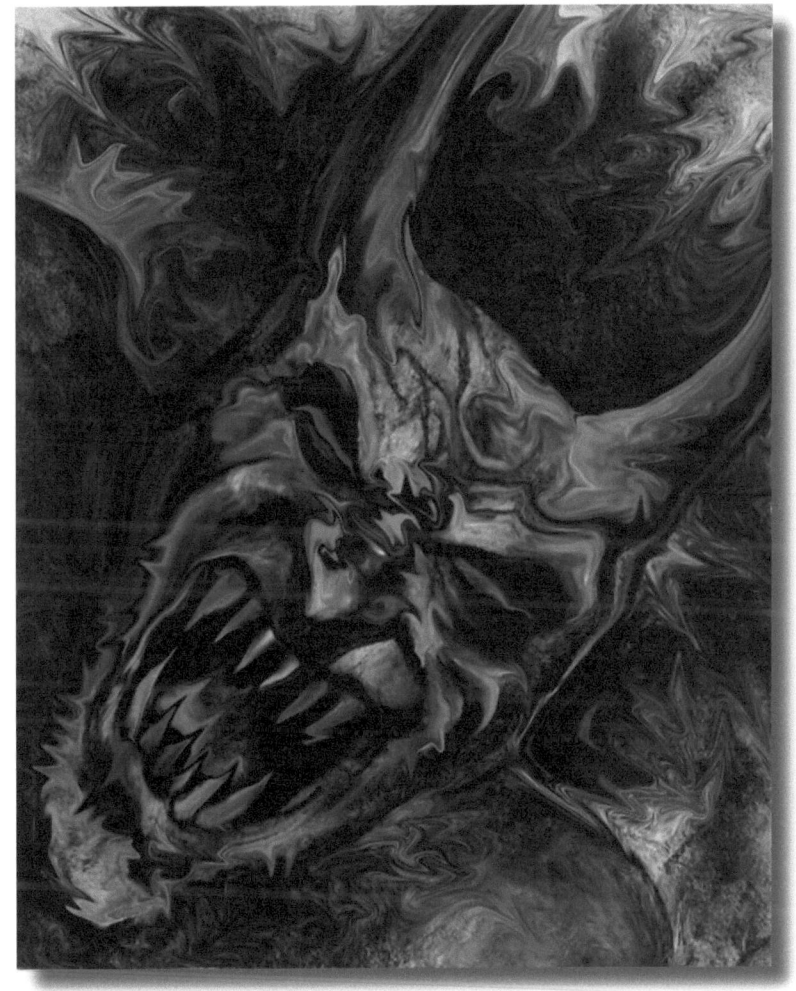

DREAMING DARK

Devil-Dogs – 2009, oil on canvas/digital media

THE FANTASY ART OF D X STONE

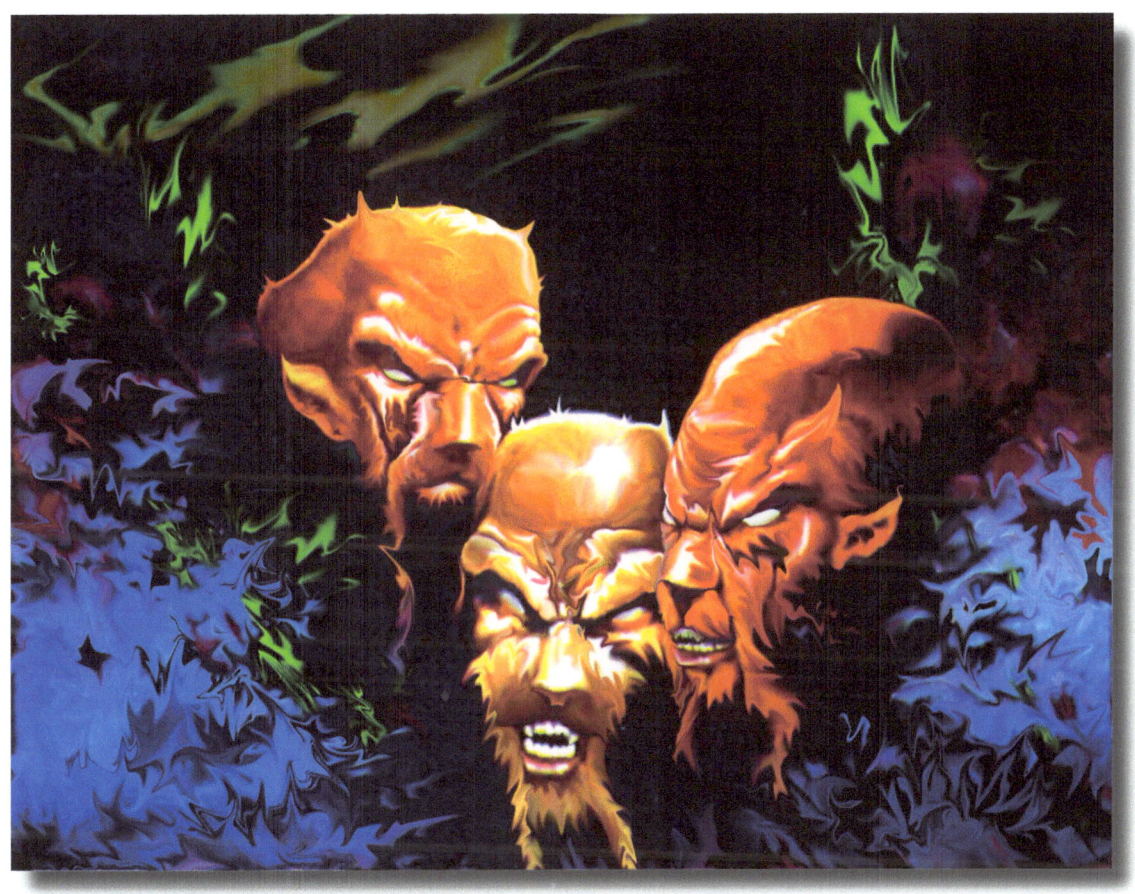

DREAMING DARK

Deep into that darkness peering
Long I stood there, wondering, fearing,
Doubting, dreaming dreams no mortal
Ever dared to dream before.

 Edgar Allan Poe, The Raven

Wurm - 1988, watercolor on vellum

THE FANTASY ART OF D X STONE

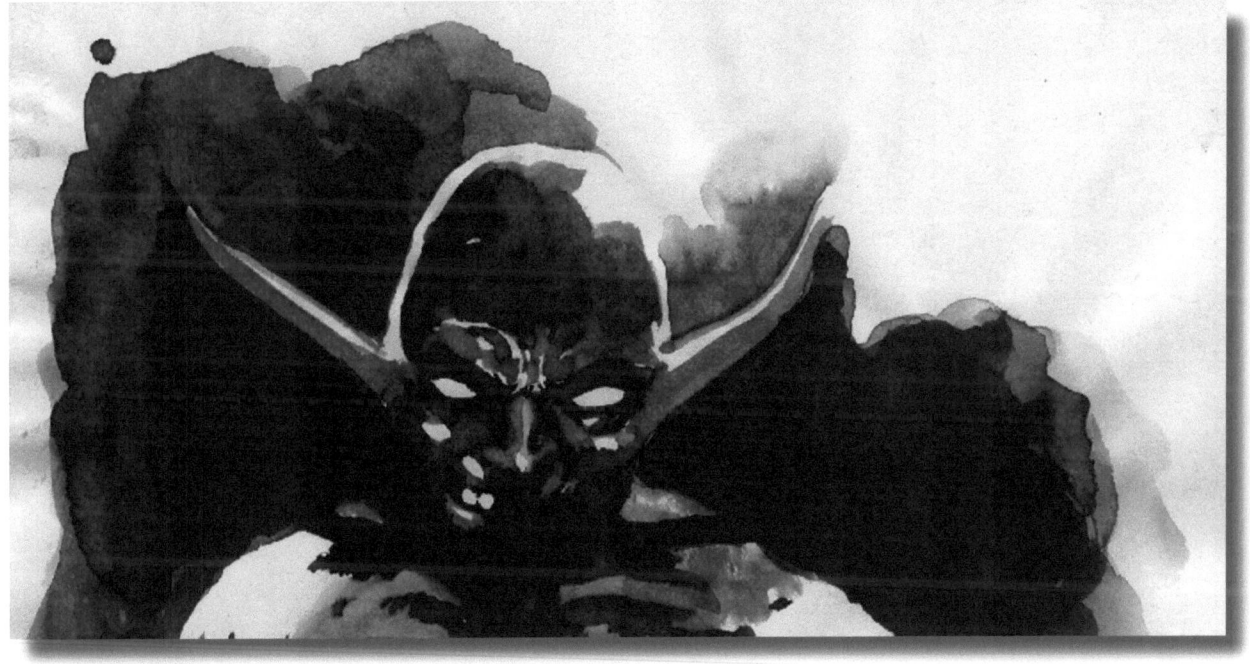

DREAMING DARK

The artist must be ready to be consumed by the fire of his own creation.

Auguste Rodin

I put my heart and my soul into my work, and have lost my mind in the process.

Vincent Van Gogh

Thumb-Thinger-Other - 2008, watercolor

THE FANTASY ART OF D X STONE

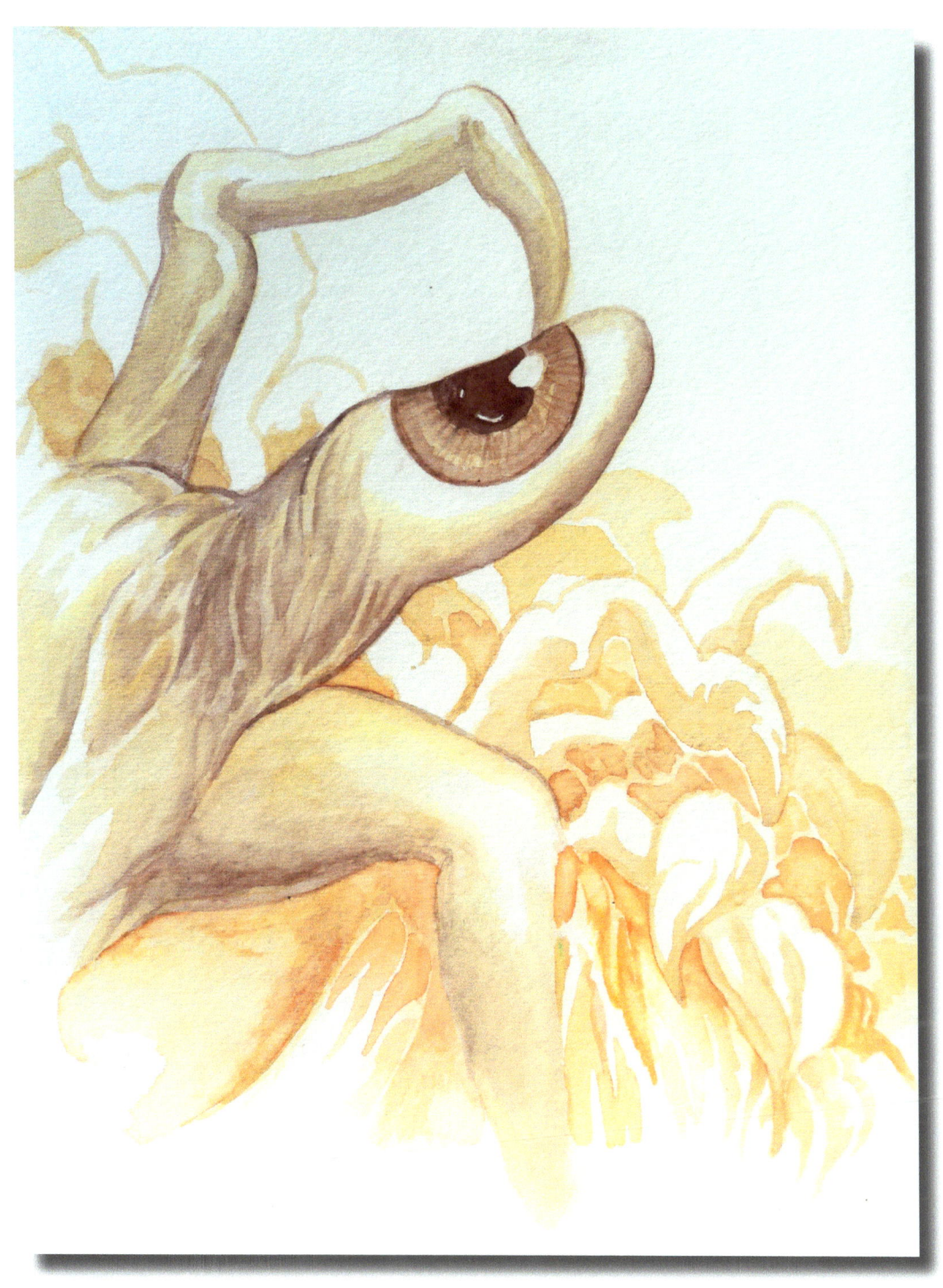

DREAMING DARK

If there is a
transmigration of souls,

then I am not yet on

the bottom rung.

My life is a hesitation
before birth.

Franz Kafka

All the things one has forgotten scream for help in dreams.

Elias Canetti

Demon II – 2011, oil/digital media

THE FANTASY ART OF D X STONE

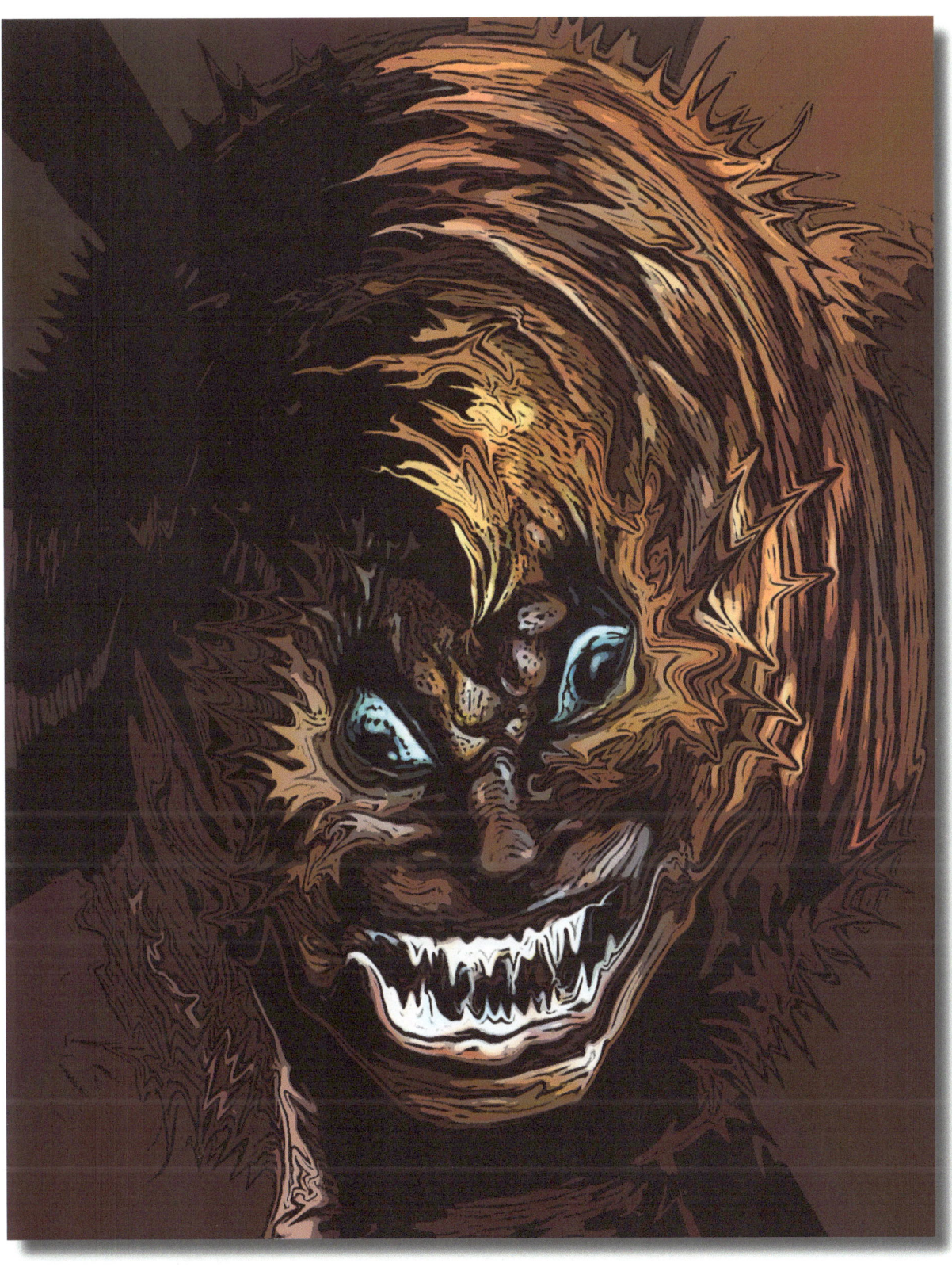

DREAMING DARK

Give them pleasure. The same pleasure they have when they wake up from a nightmare.

Alfred Hitchcock

There is no delight the equal of dread.

Clive Barker

Shiny Shiny! – 1985, oil on canvas

THE FANTASY ART OF D X STONE

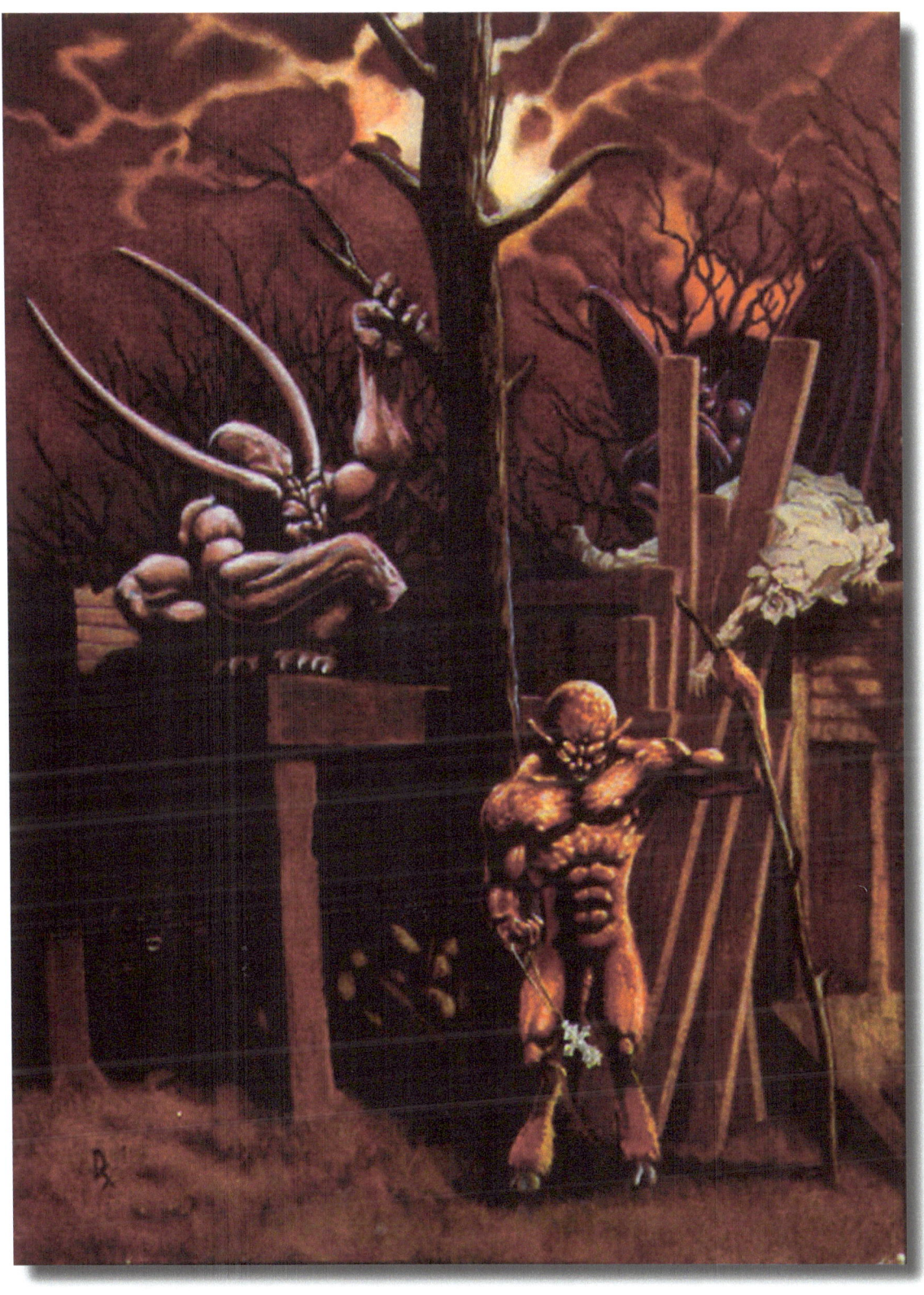

DREAMING DARK

Remember to always be yourself.

Unless you suck.

Joss Whedon

Sucker – 1988, oil on canvas

THE FANTASY ART OF D X STONE

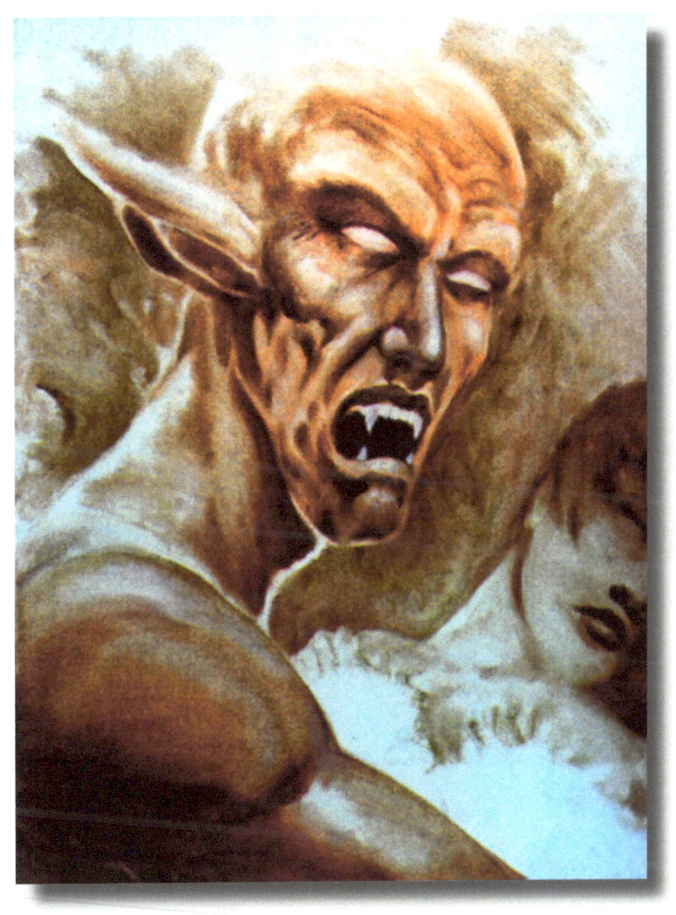

DREAMING DARK

Alice had got so much into the way of expecting nothing but out-of-the-way things to happen, that it seemed quite dull and stupid for life to go on in the common way.

"From the moment I fell down that rabbit hole, I've been told what I must do and who I must be. I've been shrunk, stretched, scratched and stuffed into a teapot! I've been accused of being Alice and of not being Alice, but this is my dream...

I'll decide where it goes from here."

I LOVE horror movies, man...
I just don't want to *live* in one.

D X Stone

Lamia II – 2011, watercolor/digital media

THE FANTASY ART OF D X STONE

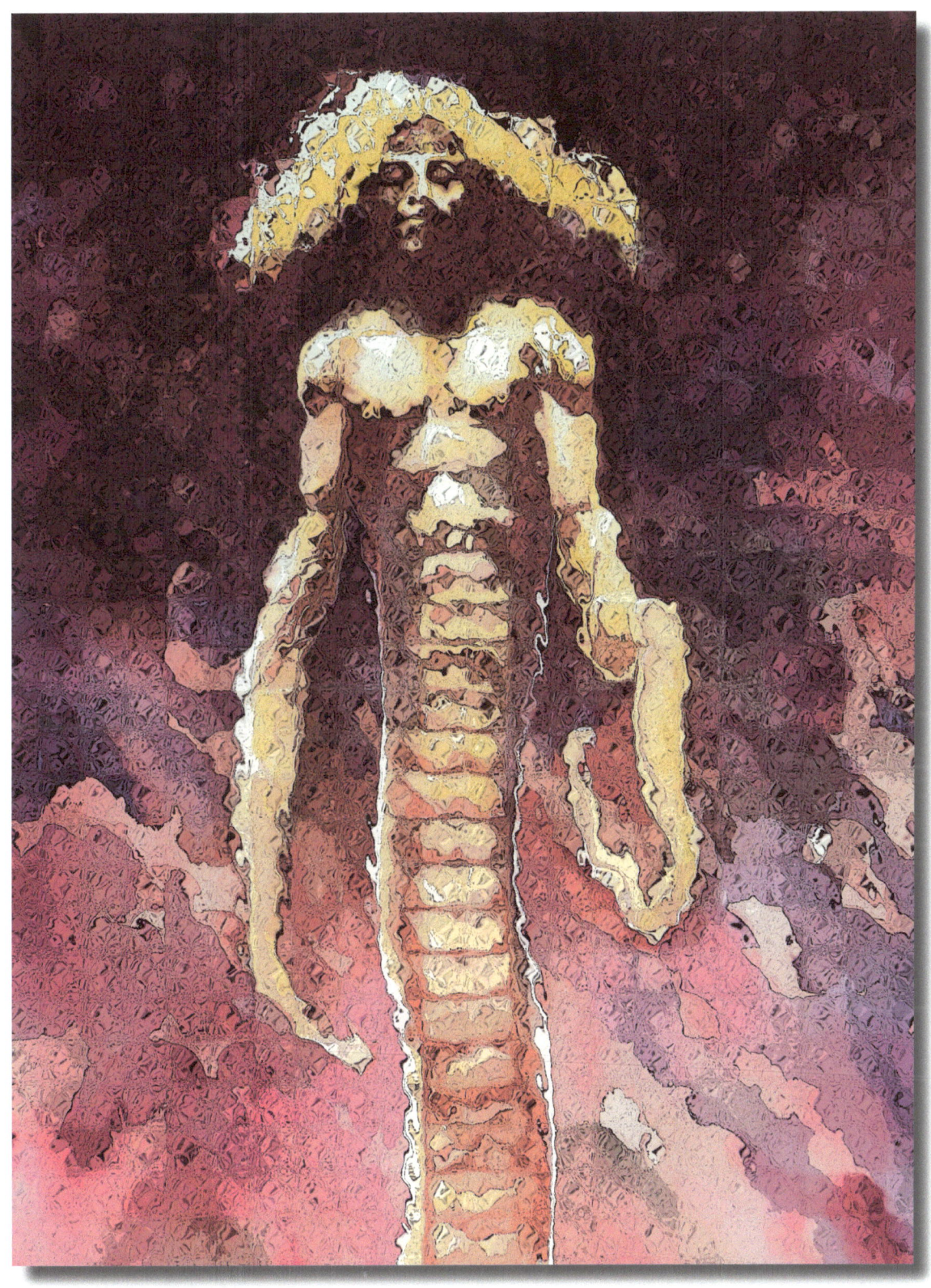

ABOUT THE ARTIST

D X Stone is a multidisciplinary creative being living in a constant state of endless, often joyous becoming. Hailing from the grey hills of Cleveland, Ohio, she wrestled with the bewildering and intolerable dilemma of such an accursed genesis for several decades before finally achieving escape velocity from that gloomy, ever-brooding and inhabitable land when she changed her name, sex and hair color all at once, and slipped out the back way one dark moonless night to avoid detection by the hideous invisible space pumpkins that hover malevolently over our unfortunate planet like clouds, and feed off human pain and occasional cheese puffs—a food apparently unlike any other in any of the known universes, which of course makes them highly prized by many other alien races, who, unbeknownst to most of us, partake of our exquisite capacity for agony, and our snacks, at their leisure—despite the fact that most of them, like most humans, actually think cheese puffs taste pretty much like eating stale old bubble wrap.

So don't be surprised by the worldwide cheese puff shortages coming soon. You've been warned.

She currently resides in warm, sunny southern California, which in itself is the happy culmination of one of her fondest lifelong dreams—getting the hell out of Cleveland, Ohio.

www.ingramcontent.com/pod-product-compliance
Lightning Source LLC
Chambersburg PA
CBHW050943200526
45172CB00020B/562